MARTINE SYMS
NEURAL SWAMP

**Edited by
Irene Calderoni and Amanda Sroka**

**The Future Fields Commission
in Time-Based Media**

**Published in association
with Yale University Press
New Haven and London**

Fondazione Sandretto Re Rebaudengo, Turin

Philadelphia Museum of Art

PUBLISHED ON THE OCCASION OF THE EXHIBITION
MARTINE SYMS: NEURAL SWAMP / THE FUTURE
FIELDS COMMISSION

FONDAZIONE SANDRETTO RE REBAUDENGO
NOVEMBER 5, 2021 — MARCH 27, 2022
PHILADELPHIA MUSEUM OF ART
MAY 14 — OCTOBER 30, 2022

Produced by the Publishing Department
Philadelphia Museum of Art
2525 Pennsylvania Avenue
Philadelphia, PA 19130-2440
philamuseum.org

Published in association with
Yale University Press
302 Temple Street
P.O. Box 209040
New Haven, CT 06520-9040
yalebooks.com/art

Inside cover image

Martine Syms (American, b. 1988).
NEURAL SWAMP (still), 2021

The exhibition at the Philadelphia Museum of Art was made
possible by the Daniel W. Dietrich II Fund for Excellence in
Contemporary Art and the Robert Montgomery Scott
Endowment for Exhibitions.

Martine
NEURAL
SWAMP
Syms

The Future Fields Commission
in Time-Based Media

Fondazione Sandretto Re Rebaudengo, Turin

Philadelphia Museum of Art

FOREWORD

TIMOTHY RUB
THE GEORGE D. WIDENER DIRECTOR
AND CHIEF EXECUTIVE OFFICER
PHILADELPHIA MUSEUM OF ART

PATRIZIA SANDRETTO
RE REBAUDENGO
PRESIDENT
FONDAZIONE SANDRETTO
RE REBAUDENGO

NEURAL SWAMP is a multichannel video installation created by the artist Martine Syms for the second Future Fields Commission in Time-Based Media, a program established in 2016 by the Philadelphia Museum of Art and the Fondazione Sandretto Re Rebaudengo to commission, exhibit, and acquire work by some of the most innovative artists practicing today. Inaugurated in 2018 with Rachel Rose's WIL-O-WISP, this partnership is intended to encourage the creation of new, ambitious work by artists whose practices are redefining the field of time-based media—whether in film, video, digital media, sound, or performance—and who are at a pivotal juncture in their careers.

The Future Fields Commission supports the artist financially and institutionally throughout the creation of the commissioned work, reflecting the museum's and foundation's goal to advance and preserve the art of our time. This shared commitment to artistic experimentation and growth unites us and remains at the center of our collecting and programming efforts.

The commission is awarded biennially through a nominating process. Syms's selection was

decided by an international group that included Vic Brooks, senior curator of time-based visual art at EMPAC / Curtis R. Priem Experimental Media and Performing Arts Center at Rensselaer Polytechnic Institute and co-chair of the Contemporary Curatorial Workshop at the Williams Graduate Program in the History of Art; Zasha Colah, an independent curator based in Italy and India and cofounder of Clark House Initiative; Inti Guerrero, the Estrellita B. Brodsky Adjunct Curator of Latin American Art at Tate, London, and artistic director of Bellas Artes Projects in Manila/Bataan; Polly Staple, Director of Collection, British Art, at Tate, London; and Kaelen Wilson-Goldie, a writer and critic based in Beirut and New York.

Syms, one of the most exciting and original artists working in the field of time-based media, is known for exploring the complex politics of representation through her illuminating investigations into Blackness across a range of technologies and media. In earlier projects, Syms developed custom applications, algorithms, and virtual-reality programs. With the Future Fields Commission, we saw an opportunity to offer the time and resources for Syms to expand her practice in new directions. NEURAL SWAMP marks her most extensive endeavor to date working with artificial intelligence. Observing the ways that machines attempt to mimic the workings of the human mind and analyzing the psychological and sociopolitical implications of these processes, Syms began to develop her own "neural swamp" in the form of a total work of art that is at once singular and complete, yet always in the process of becoming. Her research for the development of this work was informed by a fellowship in the Berggruen Institute's Transformations of the Human program and a Google Artists + Machine Intelligence residency. In engaging with new technologies, the possibilities and limits of which are still being tested, Syms exemplifies the experimentation and revolutionary thinking that we aspire to promote through the Future Fields Commission. The work itself—the bodies/monitors speaking with virtual voices, attempting to find connection in an artificial terrain—also feels starkly emblematic of our current moment. "In a world full of screens," the artist asked in an early prospectus for the work, "what is the space of living, breathing entities?" As the crisis of the global pandemic evolves from a temporary emergency to a structural condition, NEURAL SWAMP is a provocative response to the virtualization and distancing that have become hallmarks of contemporary life.

Our heartfelt thanks go to Martine Syms, who, over a period of production extended and complicated by the pandemic, dedicated her talent and energy to the creation of a work that has served as a bridge to new projects and will continue to enrich the collections of both the Philadelphia Museum of Art and the Fondazione Sandretto Re Rebaudengo in the years to come. The project's curators, Irene Calderoni and Amanda Sroka, played an important role in facilitating a multifaceted production and installation process. We warmly thank them for their fundamental contributions to the realization of both the commission and this book, another vital aspect of the Future Fields initiative. In addition to their perceptive texts, this volume includes an insightful essay by Christina Sharpe that provides an essential theoretical and cultural framework for understanding Syms's work, and is further enhanced by a visual essay provided by the artist. We offer our sincere thanks to them and to the many others who contributed to the creation of this striking book.

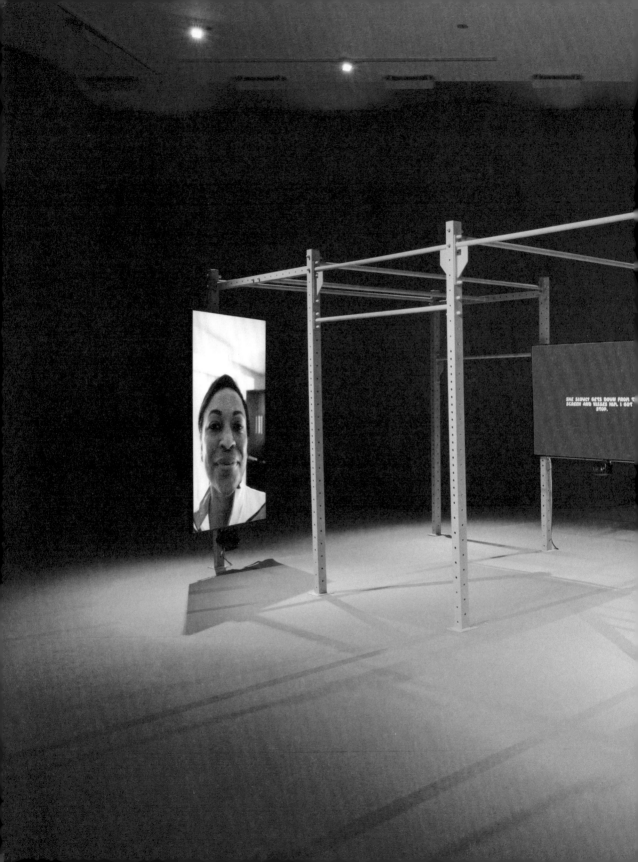

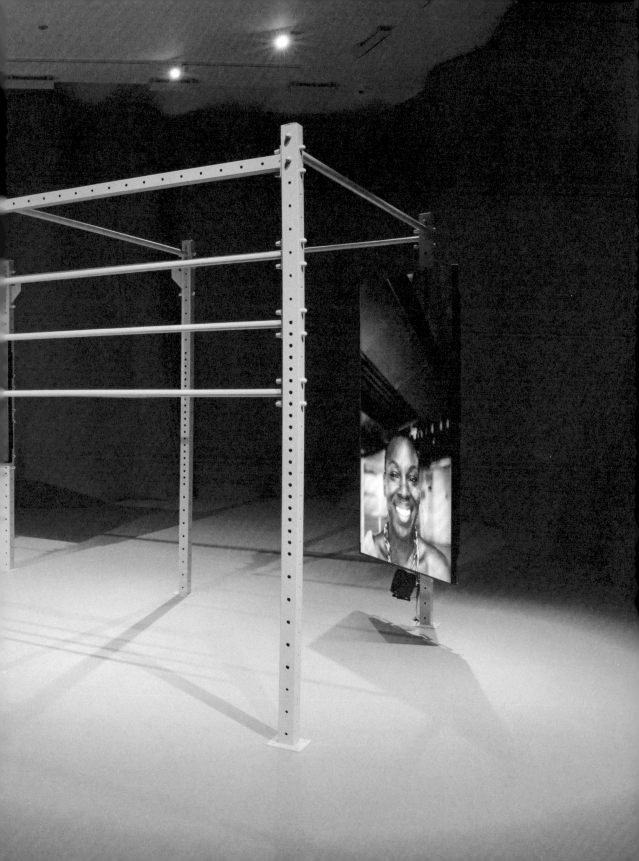

A WORLD OF SCREENS

AMANDA SROKA

Martine Syms's NEURAL SWAMP is a new digital work and environmental installation created for the second Future Fields Commission in Time-Based Media. Had it premiered in the fall of 2020, as originally intended, this essay might have been written differently. But today Syms's work and its relationship to technology have newfound resonance. The development of this commission, like much of life over the last two years, was a process that unfolded over—and on—screens. Through the conditions of an ongoing global pandemic, our dependence on screens for work, pleasure, and protest has become greater than ever. Yet for Syms, whose interest in technology predates the current moment, the screen has always been as much a space for ecstasy and escape as it is a platform of surveillance and capture. Mining the full spectrum of the digital—from police cameras to animated GIFs to TV commercials—her work is concerned with the politics of images and the machines and screens that allow for their production and consumption. Embracing ideas of the Black radical tradition, Afrofuturism, and Cyberfeminism, Syms deploys algorithms and avatars to question the ways in which Blackness and gender are constructed and stereotyped—both on- and off-screen.[1]

NEURAL SWAMP was conceived as a table read between three actors. Each is represented by her own video monitor, the play spread across three screens. The script's plot is seemingly mundane. Two people make plans to meet: At whose house? At what time? Who will bring the wine? Through their dialogue we meet Athena, a professional golfer facing the decline of her career, and her assistant and friend, Dee. We also come to know a third character, named Jenny, a disembodied voice that narrates Athena's and Dee's off-screen gestures and inner monologues. As in any rehearsal, with its stops and starts, words repeat and scenes return in strange loops.

But how do we distinguish between rehearsal and the performance, between practice and the game? Do such distinctions even exist?

Collapsing the realms of the lived, the seen, and the performed, NEURAL SWAMP is an investigation into what the artist terms "real-time cinema"—the idea that anything anyone does while being watched is a performance.[2] As Syms explored in her 2017 film INCENSE SWEATERS & ICE, to be seen is to perform (fig. 1).[3] This concept builds on notions of "expanded cinema" first introduced in the mid-1960s and theorized by Gene Youngblood shortly thereafter, in 1970, a time

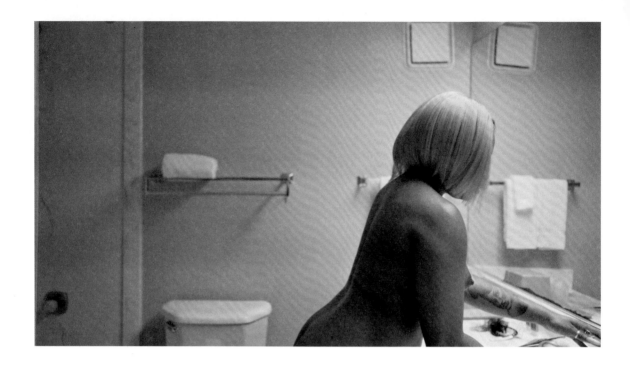

Fig. 1

Martine Syms (American, b. 1988).
Incense Sweaters & Ice (still),
2017. Video (color, sound);
69 minutes

© Martine Syms, courtesy of the
artist; Bridget Donahue, New York;
and Sadie Coles HQ, London

marked by increased public access to audio and video recording equipment and innovative developments in radio and television broadcasting.[4] Although the history of art and technology is expansive, Syms's work operates within a specific lineage of artists that includes Joan Jonas, Adrian Piper, Lynn Hershman Leeson, Ulysses Jenkins, and Shu Lea Cheang, whose work brings together performative practice, popular culture, and avant-garde technologies to challenge and question what it means to be human in an increasingly networked world.

Consider the staging that goes into even simple video calls today. Before logging on, the system asks you to preview your screen. In this virtual green room, you fix your hair, adjust your camera, and position your background. Then suddenly your coworker is in your bedroom/office, this person who, if it were not for the screens between you, might otherwise never enter the privacy of your home. But surveillance, too, is a form of real-time cinema, and the permission to capture is not always consensual.[5] As attested by pop-up ads and social-media algorithms, the data of daily life is regularly being collected, mined, and repurposed as product. Through NEURAL SWAMP,

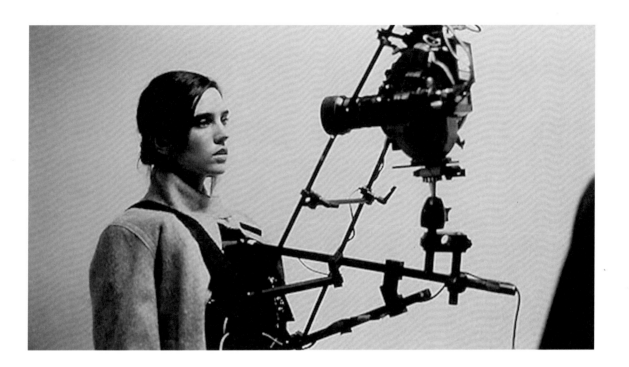

Syms engages with, and attempts to reveal, this constant state of seizure and sale, as she uses technology and refashions its interfaces.

In the making of NEURAL SWAMP, the actors were filmed using a SnorriCam, a body-mounted camera made famous by its use in iconic films such as REQUIEM FOR A DREAM (fig. 2), the psychological thriller from 2000 that, not coincidentally, features a character whose addiction to television ultimately leads to her demise. Mimicking the visual and sometimes dizzying effects of a FaceTime call, Syms fastened the cameras onto the actors, allowing them to control and document the ways in which they see and are seen.

Syms's use of the SnorriCam, strapped directly onto Black, female bodies, reflects her interest in the racialized and gendered connections that we have to the body, to memory, and to machine technologies. Part-human, part-machine, Athena and Dee foil this cyborg-state as they quite literally become technology, embodying the same instruments that we use to craft and broadcast our physical and virtual identities.[6]

Today our digital devices function as extensions of ourselves. And how we interact with them—each swipe, click, and tap—is a designed process that alters our attitudes and actions both online and when we are away from the keyboard.[7] As part of her research into these entangled connections between bodies and machines, for the development of NEURAL SWAMP Syms studied her own body as she trained in athletic activities like soccer and dance, both of which she participated in as a child. Through muscle memory, she returned to these physical activities with ease, leading her to question what new muscles are being formed through our daily use of technology. How are these interactions conditioning and surveying our subjectivities and behaviors?[8]

Since the early 2000s, the phrase "phantom vibration syndrome" has been used to describe the pings and rings that haunt us even when our phones are nowhere in sight. Our perception of these vibrations and tones, embedded in our aural memory like a prosthetic, suggests our devices as another type of skin. Expanding on what the cultural historian Alison Landsberg terms "prosthetic memory," Syms's work reminds us that these surrogate "skins" are not always our own.[9]

Fig. 3

Jordan Peele (American, b. 1979) and Jonah Peretti (American, b. 1974). "Obama Deepfake" (still), 2018. From "You Won't Believe What Obama Says in This Video!," BuzzFeedVideo on YouTube, April 17, 2018

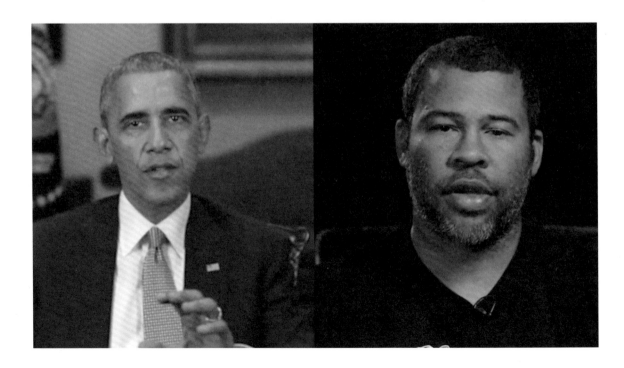

In the production of **NEURAL SWAMP**, the voices of the three protagonists were recorded separately from the filming of the bodies that those voices occupy onscreen. Using expressive AI technology, Syms created "voice skins" for the characters, each composed of various audio samples scraped from the internet and stitched together like a digital ready-made. This construction and manipulation of the voice can be likened to the production of a deepfake, a term used to describe AI-generated videos of people saying and doing things they never actually said or did. Such videos were first popularized in the pornography industry—typically through swapping the faces of well-known actors onto the bodies of porn stars—and are increasingly influential today as tools of political propaganda, as Jordan Peele warned with his deepfake of Barack Obama expounding on the dangers of fake news (fig. 3).[10] With "deep learning" software, algorithms are designed to operate in a similar way to the human brain, forming layers of artificial neural networks as the machine "trains" and "grows." For **NEURAL SWAMP**, the machine voice learned the cadence and inflections of its character—Athena's more brash, Dee's more submissive, and Jenny's more monotone. Syms considers the voice a "fingerprint of the body";[11] through machine learning technologies, **NEURAL SWAMP** tests the limits of just how deeply that fingerprint can be faked.

Further exploring the human possibilities of the machine, the script that Athena, Dee, and Jenny enact is constructed in real time using a text-generating algorithm. The result is a glitch between the faces we see, the voices we hear, and the words that are said—a dissonant effect that echoes the ways in which our digital devices have become mediums for distraction and displacement.

Color has always played an important role in Syms's installations, and the bright green environment of **NEURAL SWAMP**—designed to resemble a golf course-cum-stage set—functions on more than one level. In filmmaking a green screen is used as a post-production special effect, similar to a deepfake, that allows actors to inhabit places they never visited and encounter people they never met. It is cinema's own smoke and mirrors. In **NEURAL SWAMP** the entire installation, from the floor to the hardware to the walls, takes on this transmutable green.[12]

On the screens, footage of the characters is interspersed with scenes of digital golf simulations, a direct reference to Athena's former life as a professional athlete—a lifestyle in which, for Black athletes

in particular, to perform is to be scrutinized. Athena was also the subject of Syms's 2019 work CAPRICORN (fig. 4), a short video of the golfer at a driving range rendered in a mix of close-up and action shots and set to a moody electronic soundtrack reminiscent of a Nike ad. Commenting on the glorification and exploitation of Black women athletes, Syms's work speaks to the ways in which sports, like screens, are platforms where perfection and entertainment are demanded, often to the point of exhaustion. As Christina Sharpe documents in her essay "Staying in It" (pp. 32–46), there are numerous examples of Black women athletes who have received criticism not only for refusing to meet capitalist expectations of performance but also for their very excellence. Nevertheless, they persevere. "After all," asked the poet and cultural critic Hanif Abdurraqib, "what is endurance to a people who have already endured?"[13]

Syms's KITA'S WORLD series, also created over the course of NEURAL SWAMP's production, is yet another exploration into the increasing technological mediation of our everyday lives—described by the artist as an investigation into "the problem of the psychosomatic slip in

Fig. 4

Martine Syms. *Capricorn* (still), 2019. HD video (color, sound), 1:37 minutes

© Martine Syms, courtesy of the artist and Bridget Donahue, New York

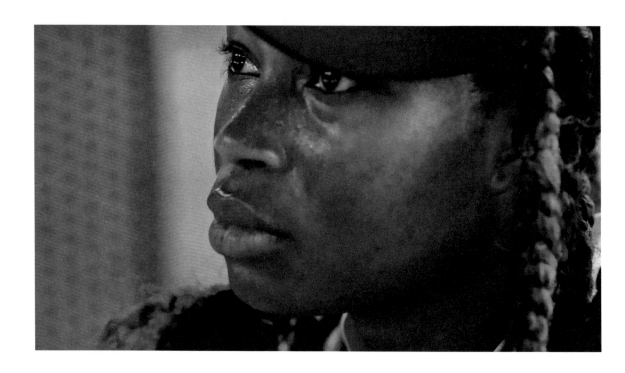

the digital era."[14] The KITA'S WORLD videos riff on the video music show CITA'S WORLD, which premiered on BET in the late 1990s and represented the first TV show to feature a Black virtual-reality character as host. In Syms's videos, Kita's roles range from meditation guru to cultural commentator. In SOLILOQUY (fig. 5), for example, Kita's DJ set intersperses music videos by rap icons like Missy Elliott and Puff Daddy with found footage referencing challenging histories of capital and empire. At one point in the script for NEURAL SWAMP, Athena and Dee watch Kita on TV. Underscoring the commercialization and fetishization of Black cultural production, KITA'S WORLD provides another perspective into the lives of Athena and Dee and demonstrates the interconnectedness of the artist's oeuvre.

Syms's work blurs the lines between humor and horror and holds a funhouse mirror to the flesh and mess behind our screens, both reflecting and refracting our everyday rehearsals. It is a reminder that, like NEURAL SWAMP itself, we too are constantly in a state of production. And in our world full of screens, you fake it till you make it.

Fig. 5

Martine Syms. *Soliloquy* (still), 2021. From the *Kita's World* series. Digital video (color, sound), 7:14 minutes

© Martine Syms, courtesy of the artist and Bridget Donahue, New York

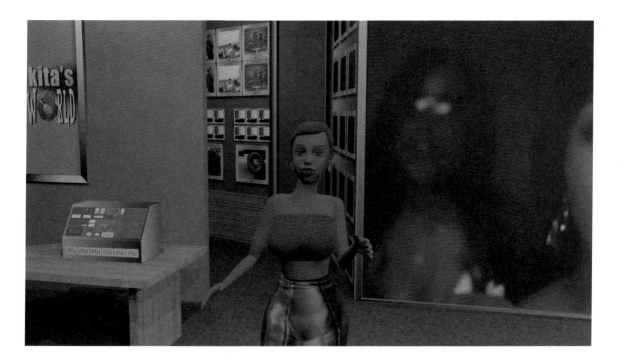

1. Elaborating on the meaning behind the multifarious artistic approach that Syms embraces, Katherine McKittrick writes, "Black people have always used interdisciplinary methodologies to explain, explore, and story the world, because thinking and writing and imagining across a range of texts, disciplines, histories, and genres unsettles suffocating and dismal and insular racial logics. By employing interdisciplinary methodologies and living interdisciplinary worlds, black people bring together various sources and texts and narratives to challenge racism. Or, black people bring together various sources and texts and narratives not to capture something or someone, but to question the analytical work of capturing, and the desire to capture, something or someone." McKittrick, *Dear Science and Other Stories* (Durham, NC: Duke University Press, 2020), 4.

2. Martine Syms, "Episode Two: (In)Visibility," *Mirror with a Memory* podcast, Carnegie Museum of Art, Pittsburgh, February 8, 2021 (4:03), cmoa.org/art/hillman -photography-initiative/mirror-with-a-memory/podcast/.

3. "The relation to the self, the relation to the world, the relation to the other: all are constituted through a *reversibility* of seeing and being seen, perceiving and being perceived." Amelia Jones, *Body Art / Performing the Subject* (Minneapolis: University of Minnesota Press, 1998), 41.

4. See Gene Youngblood, *Expanded Cinema* (New York: Dutton, 1970).

5. We each have a distinct relationship to this performance—to the production and distributions of our worlds. See David Robbins's *High Entertainment* project, davidrobbinsartist.com/high-entertainment/.

6. In this way, Syms's work harkens back to notions of the cyborg first introduced by Donna Haraway in her 1985 "A Cyborg Manifesto," written at the height of the Reagan era and in the final years of the Cold War (first published in the *Socialist Review*, Haraway's essay was reprinted six years later in *Simians, Cyborgs and Women: The Reinvention of Nature* [New York: Routledge, 1991], 149–81). Haraway's cyborg served as a tool to investigate and trouble traditional notions of gendered and racialized bodies. Part-human, part-animal, part-machine, the cyborg merged the technological and the biological and represented a

kaleidoscopic interrogation that addressed feminist studies and post-humanist theory. Haraway's writing has since been built on, questioned, and problematized by scholars and artists, including Haraway herself and, most recently, Legacy Russell in *Glitch Feminism: A Manifesto* (New York: Verso Books, 2020).

7. "AFK" (away from the keyboard) as opposed to "IRL" (in real life) is used throughout Russell's *Glitch Feminism*.

8. Syms explains: "I was doing all this work about movement, looking at vernacular movements, like gesture and body language and the more psychological side of movement. Someone suggested I think about dance, so I started going to this dance class. In childhood I did ballet for many years, with my best friend who went on to join a dance company. As I started to reinvestigate dance in my own body, I realized how much these movements and the muscle memory had shaped and conditioned me. When I started playing soccer again, the feeling was crazy, like, I *know* how to do this thing. These experiences are just so ingrained in your body." See Syms, interview by Steffani Jemison, *BOMB Magazine*, November 13, 2020, bombmagazine.org/articles/martine-syms/.

9. In her book *Prosthetic Memory: The Transformation of American Remembrance in the Age of Mass Culture* (New York: Columbia University Press, 2004), Landsberg elaborates on the idea of prosthetic memory as a way to think expansively about identity as it relates to a sense of memory and time rooted not in lived experience but instead in a shared social familiarity with cultural texts, such as films and books, but also GIFs, Vine videos, and memes.

10. David Mack, "This PSA about Fake News from Barack Obama Is Not What It Appears," BuzzFeed News, April 17, 2018, www.buzzfeednews.com/article /davidmack/obama-fake-news-jordan-peele-psa-video-buzzfeed.

11. Martine Syms, in a Zoom call with the authors on April 6, 2021.

12. One of the first examples of the use of a green screen in cinema (which at the time was not green but black) was in the 1933 horror movie *The Invisible Man*, based on the science-fiction novel of the same name by H. G. Wells.

13. Writing about Black performance in *Little Devil in America*, Abdurraqib elaborates:
 "What is it to someone who could, at that point, still touch the living hands of a
 family member who had survived being born into forced labor? Endurance, for
 some, was seeing what the dance floor could handle. It did not come down to the
 limits of the body when pushed toward an impossible feat of linear time. No. It was
 about having a powerful enough relationship with freedom that you understand its
 limitations." Abdurraqib, *Little Devil in America: In Praise of Black Performance*
 (New York: Random House, 2021), 9.

14. See Mark Westall, "Shortlist for Inaugural Rolls-Royce Moving-Image Dream
 Commission," *FAD Magazine*, October 22, 2020, fadmagazine.com/2020/10/22
 /shortlist-for-inaugural-rolls-royce-moving-image-dream-commission/.

WORKING

AND REFERENCE

IMAGES

STAYING IN IT

CHRISTINA SHARPE

The room is bathed in green light. At the center is a green metal structure that resembles a workout station. To either side a monitor plays video of a woman speaking, Athena on one side, and Dee on the other. On a third monitor, displaying text and images (initially conceived as a large screen; fig. 6), we hear the narrator, Jenny. In this immersive, multichannel work, the content of each of the three monitors is generated by AI and synchronized through two algorithms, one for the voices and another for the script. The characters are participating in a table read—this is a rehearsal. They are speaking, but not necessarily to each other. The green of the installation is like a green-screen background used for special effects. NEURAL SWAMP is both stage set and film.

NEURAL SWAMP is an experiment in machine learning. To be more precise, in NEURAL SWAMP the voice is data and Black women are both technology and a space onto which all kinds of desires and demands are projected. What does it mean to be a screen image? To be screen and image? To suture person and projection? These are just some of the questions Martine Syms is interested in. She describes herself as working in "broken samples, strange loops and artificial intelligence . . . to think about how various influences . . . bear down on a person."[1]

In the sensorium of NEURAL SWAMP each character is a screen, and voice is data and technology. What is real and what is fabrication when the screens are characters, and the voice is the technology? The demarcation between real and fabrication is a shifting line that Syms is always working at the limits of. It's not that Syms is invested or even particularly interested in the distinction. She's not; she's interested in the process. "My practice," she says, "foregrounds how the racialized and gendered self is mediated by technology. I work primarily in moving image, time-based media, and text. I use various tools to explore how to influence the presentation of my work."[2] In NEURAL SWAMP one of the primary visual components is textual. We see the characters' words displayed on the screen in a way that foregrounds the visual appearance of words (their onscreen arrangement, shape, spacing, and density) and the growing role of texting in cinema and how to represent it. (Earlier films by Syms experiment with how to represent texting. In INCENSE SWEATERS & ICE, for instance, the protagonist, Girl, has a relationship with a man, WB [white boy], that is conducted largely on screens and by texts.)

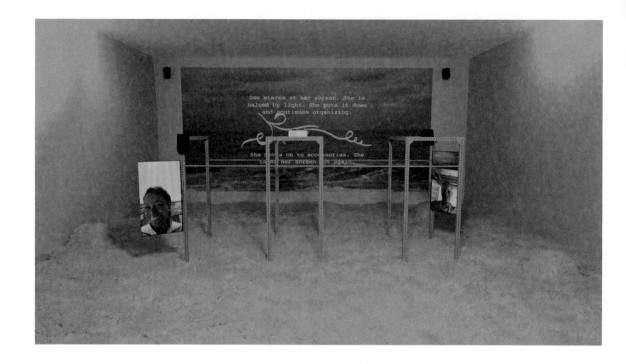

Throughout her work, Syms returns to the materiality of the body, to questions of loneliness, to mental health, to glitches, gestures, and irregularities, to screens, AI, and machine learning. She is fascinated by the forms of surveillance that have proliferated and that many of us embrace; she thinks of surveillance as a kind of "real-time cinema,"[3] whose genre is horror because of the camera angles, the graininess of the footage, the odd perspectives. Syms is interested in capture and the grammars of the body,[4] concerned with biometrics, visibility, invisibility, and "machine systems that erase, or make invisible, Black bodies, voices, and narratives."[5]

NEURAL SWAMP differs from some of Syms's earlier work with machine learning. Her 2018 MYTHICCBEING (pronounced "my thick being"), which is a play on Adrian Piper's MYTHIC BEING (1973; fig. 7), is another work about embodiment, movement, and projection. Piper's MYTHIC BEING persona explores "what would happen if there was a being who had exactly my history, only a completely different visual appearance to the rest of society"; "that's why I dress as a man," she explains.[6] Syms's MYTHICCBEING is a responsive AI-based

Fig. 6

Martine Syms (American, b. 1988). Digital study for the installation of *Neural Swamp*, 2021

© Martine Syms, courtesy of the artist

34

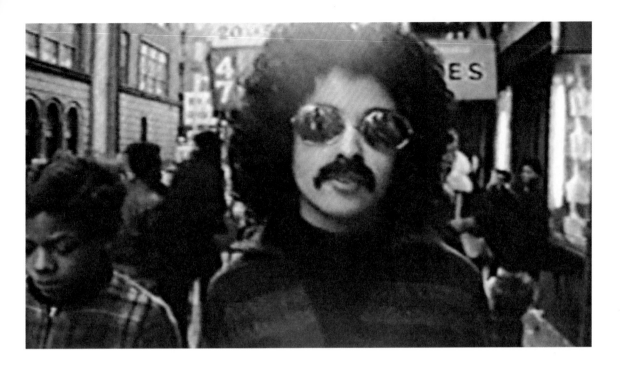

chatbot named Teenie who is embodied as a Black woman (based on Syms, and present in other works, such as SHE MAD; fig. 8). MYTHICCBEING is a digital avatar whose presence counteracts the persistent belief in the neutrality of machines and machine learning. Syms's idea was to make the machine more bodily, and to engage as well the "shadow self"—those desires and fears that we might keep hidden, even from ourselves.[7] Syms programmed MYTHICCBEING "with hours of her own personal responses that pop-up on screen through SMS interaction with visitors, . . . configur[ing] technology as a container for desire."[8] Visitors could text Teenie at certain points, controlling what would happen on the screen. But this chatbot might not answer your requests; she had her own concerns. (Syms's work, perhaps especially her work on machine learning and its capacities and limits, also brings to mind another Adrian Piper performance, FUNK LESSONS [1982–84]. The lecture-performance format of FUNK LESSONS was audience-interactive; the artist and participants danced, rehearsed, and practiced; it was performance that insisted on play. Likewise, there is a lot of play, rehearsal, and laughter in Syms's work that should not go missing from discussions of it.)

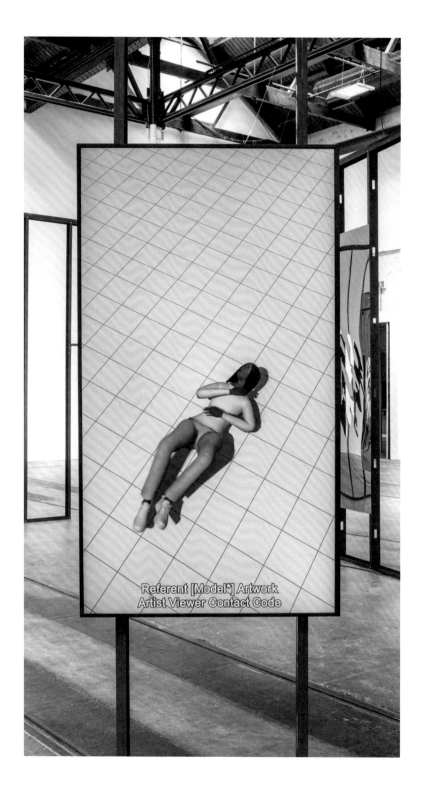

Referent [Model*] Artwork
Artist Viewer Contact Code

Fig. 8

Martine Syms. *SHE MAD S1:E4*
(still), installation at Glasgow
International, Tramway,
June 11–July 25, 2021

Commissioned by Tramway and
Glasgow International

© Martine Syms, courtesy
Tramway and Glasgow
International

In NEURAL SWAMP there is no interactive element like Teenie; the machine learning here is not in the form of direct input from an audience. There is, instead, an evolution of the machine over time because the algorithms continually generate the text and voices. There is a pedagogy to machine learning: the machine has to learn how to learn. The voices of Athena and Dee were trained on two well-known voices, while that of the narrator was trained on Syms herself. The intonations of the algorithmic voices try to mimic those of the voice models. One of the women curses a lot more than the others, and the default mode of the speakers is to curse based on what's in the algorithm. The voices of Athena and Dee were constructed and collaged from podcasts and YouTube videos. Each AI-generated speaking voice has been trained on one source, but the image is not of the person who recorded the voice. This produces an uncanny effect. But it is, in any case, impossible to reproduce the fleshiness of an individual's voice; the resonant chamber and physical vibrations of a voice are unique, like a fingerprint.

What can a voice or a body do? What can a Black body do? What is the relationship between ability and permission; between ability and interdiction; between ability and refusal; between discipline and disciplining? These are key theoretical propositions for Syms, who understands that so much of our knowledge of embodiment comes from the cinematic and from viral videos, memes, and GIFs— TikTok and the now-defunct platform Vine, where so many Black women made short looping films that, via reaction GIFs, continue to constitute an entire affective repository. For Black women, there are often two modes of performance at work and there is a tension in the push and pull between them—between policing and discipline. We are lauded and punished for innovation and ability. Some of Syms's "initial interest in technology" is in relation to this tension, in relation to "thinking about how Black women were almost, they were a kind of technology."[9]

So NEURAL SWAMP's Athena has many analog referents who, like her, are made to bear the weight of others' desires as well as those she claims as her own. At the root of the character Athena's "problem" in NEURAL SWAMP is her ejection from the golfing world and her subsequent free fall after an altercation during a game. (I'm going to guess that in Athena's backstory of that encounter, the antagonist is white. In the world of US athletics, no Black athlete's run-in with

a Black fan would precipitate any such fall.) Athena, the golf prodigy, is both rare and disposable, rare and forgettable, rare and replaceable. This is a logic that repeats; it is the logic of capital.

On May 26, 2021, Naomi Osaka posted the following statement on Instagram: "I'm writing this to say I'm not going to do any press during Roland Garros. I've often felt that people have no regard for athletes' mental health and this rings true whenever I see a press conference or partake in one. We're often sat there and asked questions that we've been asked multiple times before or asked questions that bring doubt into our minds and I'm just not going to subject myself to people that doubt me."[10] Osaka said that she was suffering from depression and would not be doing the required interviews in-between matches at the French Open. She went on to explain that her statement was not against the press nor a call for players to be released from all their press "obligations." It was, she insisted, a call for better working conditions. Five days later, on May 31, the four-time Grand Slam champion withdrew from the French Open, one day after being warned and fined by the French Tennis Federation. On June 17, Osaka withdrew from Wimbledon, "taking some personal time with friends and family."[11]

On June 20, 2021, the twenty-one-year-old sprinter Sha'Carri Richardson ran the 100 meter race in Olympic trials so impossibly fast that it made her opponents, some of the fastest women in the world, look like they were going backward. Crossing the finish line in 10.64 seconds, Richardson became the fastest woman since FloJo (Florence Griffith Joyner) ran the 100 meters in 10.49 seconds in 1988. It was electric. Less than two weeks later, Richardson was disqualified from the USA Track & Field Olympic roster, after THC showed up in a tox screening. Given the option to add Richardson to the Olympic 4x100 meter relay team, because that race would run after her ban expired, USA Track & Field declined. THC is not a performance-enhancing drug, and Richardson, whose mother had just died, said in a statement that she was smoking to "hide my pain"—"I am human," she tweeted.[12]

On July 2, 2021, in a repetition of the antiblack biometric logics used to exclude Caster Semenya from women's track and field in 2018, two Namibian runners, Christine Mboma and Beatrice Masilingi, ran the 200 meter race at the Tokyo Olympics after being barred from

participating in the 400 meter because blood tests showed "too high" levels of naturally occurring testosterone. Too high in relation to whom? On July 30 Francine Niyonsaba, a twenty-eight-year-old runner from Burundi, was disqualified after placing in the semifinal heat for the women's 5,000 meter race because she stepped on the inside rail of the track to avoid colliding with other runners. After the delegation from Burundi declined to support her challenge to the decision, Niyonsaba said that she felt "so alone."[13] But she also said, "I am not devastated. Because I know nothing can stop me. The more one tries to stop me, the stronger is my come back."[14] Niyonsaba subsequently ran in the 10,000 meter race and placed fifth, setting a new national record despite being forced to train and qualify for both that race and the 5,000 meter in order that she might be eligible to compete at all in the games.

On July 27, 2021, Simone Biles withdrew from the US Women's Gymnastics team event at the Tokyo Olympics for reasons related not to physical injury but to the "twisties," the experience of losing the sense of your body in space while executing a movement, and the difficulty of bearing the weight of expectations and demands that come with being the face of US gymnastics. Biles has won more medals than anyone else at the World Artistic Gymnastics Championships, and her skills are unmatched. But instead of being unreservedly celebrated, she has been punished for her exceptional ability. Records broken, four moves named after her, a special goat emoji (for GOAT, or greatest of all time)—yet she is not scored as highly as these moves warrant because the judges have deemed them too dangerous.

Before Osaka and Richardson, before Semenya and Niyonsaba, before Biles, there was Surya Bonaly, the Black French figure skater and nine-time French National Champion, three-time silver medalist, and five-time European champion who, in 1998 at the Nagano Olympics, executed an illegal backflip on the ice, for which she was punished. But Bonaly had, in fact, already been punished, since at every instance her Blackness confounded the judges, who lost language when it came to describing her moves, always resorting to the grammar that was familiar to them, a grammar in which she was "too athletic." "Guys," Bonaly said, "please, try to be fair."[15] When Bonaly did that backflip, she knew what she was doing and what she wanted to achieve. She wanted to push the sport into new territory.[16]

These athletes' bodies are policed, affectively and biometrically. This partial inventory is, to echo the writer and activist Audre Lorde, a litany of survival. It is a litany of continuing and an inventory of refusals. When Osaka and Biles say "no," their noes are not, or not only, a kink in the system. Their exceptional abilities are the irregularity; their responses are another kind of irregularity. Their survival, like that of all those who were not meant to survive, is yet another. What are the algorithms of survival when "black female flesh [consistently is made to function] as the limit case of 'the human'"?[17] What makes it into the algorithm, and what survives the algorithm? These are some of the questions that animate and propel Syms's work. In the swamp of expectations and projections onto Black women, the materiality of the body is central to her imagining of what life might be or is supposed to be. What are the rubrics? Is there a right way and a wrong way to make a life, to be alive?

Where is the space for breath, the space for space, the space for vulnerability? Can digital Black women live?

Syms is interested in the exhaustion of the body and the relationship between performance and perfection, the daily performance, and the question of perfectibility as well as the question of the policing and

Fig. 9

Pope.L (American, b. 1955). *How Much Is that Nigger in the Window a.k.a. Tompkins Square Crawl* (detail), 1991. Digital c-print on gold fiber silk paper, 10 × 15 in. (25.4 × 38.1 cm)

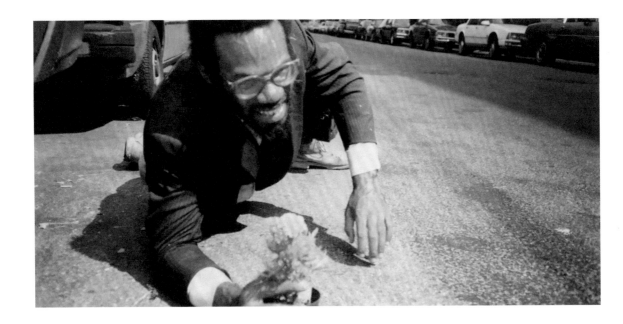

disciplining of the body. Her work is in conversation with a number of artists who provide both inspiration and points of reference. There is Piper, of course, and also Pope.L and, more recently, Stan Douglas, who employ performance-based practices (both physical and digital) to examine the ongoing performances of our everyday lives. Among the many things Pope.L's work has taught Syms is the suggestion "that I might learn something from the rub between duration and body."[18] Pope.L's decades-long practice has been one in which the body, his body, is always on the line. Those long crawls in works like TOMPKINS SQUARE CRAWL (fig. 9) push his body to its limits, enact drag and potential. Likewise, Douglas's video work SUSPIRIA (fig. 10), which is algorithmic and changes with each telling, pushes the boundaries of storytelling and probes borders, such as the relationship between AI and the camera. Douglas interrogates how the camera sees.

For Black women, in particular, there are two modes of performance at play and a tension between those modes, that tension between policing and discipline: discipline in terms of what you can train a body to do without exceeding its limits, and discipline as in policing. What a body can do changes when you change the race or sex or gender or class of the body in question. We may ask again: What can a Black body do? What is the relationship between ability and permission? Between ability and interdiction? Between ability and refusal? What is the relationship between algorithm and "threat"? What are the "limits of possibility"?[19]

All of the Black athletes in that earlier litany have, at the height of their skills, asserted their independence and the particularity of their fleshly being. Each has tried to make some other way to be. Similarly, Syms's staged environments—KITA MEDITATING (2021), MYTHICCBEING (2018), NOTES ON GESTURE (2015)—are experiments, rehearsals, in living and being.

Martine and I had a conversation in late May 2021 in which we talked about her work, about voice and AI, about trauma and wounds breaking open. We talked about the fourteen months of pandemic deaths and restrictions, and about extraction and human environmental costs, Amazon warehouses with ambulances parked outside, cloud capacity, humans working in mines, and underground data centers. She tells me about a significant moment in her time as a fellow with the Berggruen Institute in Los Angeles when she was

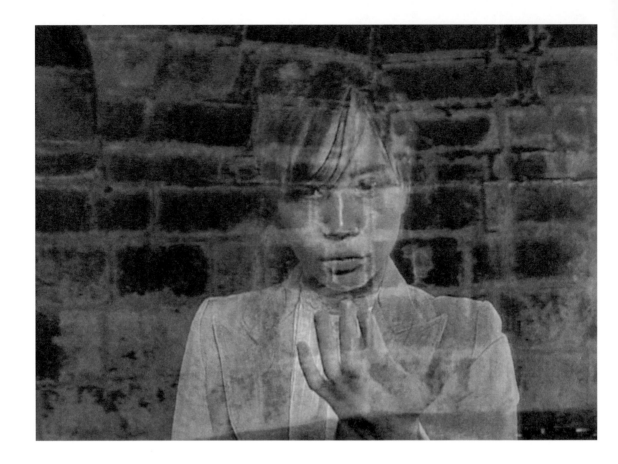

delving even deeper into research on AI and voice. She was in the
midst of figuring out how to replicate her voice (for Jenny) and two
other voices (for Dee and Athena), and she was reaching the limits
of what was possible.

One of the other fellows, Stuart J. Russell, a professor of computer
science at the University of California, Berkeley, and an expert on AI
systems, told Syms that when he was working on machine learning he
discovered early on that he and his colleagues had to alter how they
programmed the algorithm, because the AI learned very quickly that
the easiest way to get a desired result was through sadism. We each
sit with that knowledge, astonishing but not surprising, that one must
adjust for sadism. Syms is trying to get at the scale of these systems
we are implicated in, these massively extractive systems that we

make use of—what Kate Crawford describes as a "planetary system of computation and extraction."[20] Syms tells me, "I want to stay in it and be aware of everything that comes with that." I hear in that statement a declaration, a determination not to turn away, and an embrace of radical awareness.

To "stay in it" is to try to know this particular interplay of extraction, the uses of Black bodies, and how the possible otherwise emerges. To stay in it is to refocus our attention, to try to take in, up close, as much as possible of what goes on under our feet, or under our noses, or in our names. To stay in it is also, and by necessity, to experience what Syms calls irregularity: a word and concept that approaches one's experience of technology and everyday life. Syms explains it as "your everyday use of technology . . . your experience of it, and when you experiment with it, there are irregularities and there are malfunctions and there are surprises to it. It does not work perfectly. Ever. But neither does anything else, and I think that's a quality of life that we can all recognize as true."[21] We are necessarily participants in irregularity; it is a quality of life. Syms made NEURAL SWAMP in the midst of the COVID-19 pandemic, in the midst of borders closing, stay-at-home orders, and the deaths of millions of people around the world. She stayed in it. What might the work do as it enters our irregular now?

1.	Martine Syms, "Episode One: Biometrics," *Mirror with a Memory* podcast, Carnegie Museum of Art, Pittsburgh, February 1, 2021 (3:17), cmoa.org/art/hillman-photography-initiative/mirror-with-a-memory/podcast/.

2.	"When Your Voice Is the Dataset: The Inspiration behind Martine Syms' New Interactive Video Installation, *Neural Swamp*," Google Arts & Culture, artsandculture.google.com/story/_QWxHHXcmCBDxw.

3.	Syms, "Episode Two: (In)Visibility," *Mirror with a Memory* podcast, Carnegie Museum of Art, Pittsburgh, February 8, 2021 (4:03), cmoa.org/art/hillman-photography-initiative/mirror-with-a-memory/podcast/.

4.	Amanda Sroka, description of *Neural Swamp*, Contemporary Art department, Philadelphia Museum of Art.

5.	Sroka, description of *Neural Swamp*.

6.	Adrian Piper, "'*The Mythic Being*,' at MAMCO, Geneva: Elise Lammer and Karima Boudou in Conversation," *Mousse Magazine*, April 1, 2018, www.moussemagazine.it/magazine/adrian-piper-mythic-mamco-geneva/.

7.	The text for *Mythiccbeing* comes from *Shame Space*, Syms's book of diary-like entries and meditations, a contemplation of what happens when the source materials for work are things that you might otherwise not share. There they appear with a kind of bravado.

8.	Kathryn O'Regan, "'Anything you do on camera is like a performance'—LA Artist Martine Syms on Being Seen in a Surveillance Society," *Sleek*, January 7, 2019, www.sleek-mag.com/article/martine-syms-2019/.

9.	Syms, in Annie Armstrong, "Smarter Child," *Garage Magazine,* October 30, 2020, garage.vice.com/en_us/article/epd47p/smarter-child.

10.	See Jackie Spiegel, "Naomi Osaka Says She Will Not Speak to Press at 2021 French Open, Citing Mental Health," *Sporting News*, May 26, 2021, www.sportingnews.com/us/tennis/news/naomi-osaka-press-2021-french-open-mental-health/6htmtd96fm3d14qql2265988v.

11. Claire Lampen, "Naomi Osaka Has Withdrawn From Wimbledon," The Cut, June 17, 2021, www.thecut.com/2021/06/naomi-osaka-announces-withdrawal-from -wimbledon.html.

12. See Emily Kirkpatrick, "'I Was Trying to Hide My Pain': Sha'Carri Richardson Disqualified from Olympic Race after Marijuana Use," *Vanity Fair*, July 2, 2021, www.vanityfair.com/style/2021/07/sha-carri-richardson-tests-positive-marijuana -no-olympic-races.

13. Gerald Imray, "'So alone': Niyonsaba Criticizes Own Team after Olympics DQ," *Seattle Times* (via Associated Press), July 30, 2021, www.seattletimes.com/sports /olympics/so-alone-niyonsaba-criticizes-own-team-after-olympics-dq/.

14. Cyd Ziegler, "Francine Niyonsaba Fought for Her Right to Compete: The Olympics Disqualified Her in Tokyo," Outsports, July 31, 2021, www.outsports.com /olympics/2021/7/31/22603734/francine-niyonsaba-tokyo-olympics.

15. "What she saw as unfair treatment from the judges had become routine." From "'Please, Try to Be Fair': Bonaly Confronts 1994 World Championships Loss," *WBUR On Point* podcast, March 7, 2019, www.wbur.org/onpoint/2019/03/07/surya -bonaly-skating-losers-netflix.

16. "Surya Bonaly's Backflip; Official Clip; Losers; Netflix," YouTube, March 22, 2019, www.youtube.com/watch?v=_rE_4_CCEgc.

17. Zakiyyah Iman Jackson, *Becoming Human: Meaning and Matter in an Antiblack World* (New York: NYU Press, 2020), 4.

18. Syms, "Being Horizontal" [on *Times Square Crawl a.k.a. Meditation Square Piece*], in *member: Pope.L, 1978–2001*, ed. Stuart Comer and Danielle Jackson (New York: Museum of Modern Art, 2019), 47.

19. Syms, "Episode Five: Land," *Mirror with a Memory* podcast, Carnegie Museum of Art, Pittsburgh, March 1, 2021 (10:26), cmoa.org/art/hillman-photography-initiative /mirror-with-a-memory/podcast/.

20. Syms, "Episode Five: Land," *Mirror with a Memory* podcast, Carnegie Museum of
 Art, Pittsburgh, March 1, 2021 (8:41), cmoa.org/art/hillman-photography-initiative
 /mirror-with-a-memory/podcast/. In this episode Kate Crawford talks about
 the vast resources used in order to ask Alexa an insignificant question. As she
 explained earlier: "But in this fleeting moment of interaction, a vast matrix of
 capacities is invoked: interlaced chains of resource extraction, human labor and
 algorithmic processing across networks of mining, logistics, distribution, prediction
 and optimization. The scale of this system is almost beyond human imagining";
 quoted in Crawford and Vladan Joler, *Anatomy of an AI System: The Amazon Echo
 As an Anatomical Map of Human Labor, Data and Planetary Resources*, 2018,
 i, anatomyof.ai/. Knowledge of the scale of extraction is part of what Syms is
 speaking about when she says that she wants to "stay in it."

21. Syms, "Episode Four: Storytelling," *Mirror with a Memory* podcast, Carnegie
 Museum of Art, Pittsburgh, February 22, 2021 (4:05), cmoa.org/art/hillman
 -photography-initiative/mirror-with-a-memory/podcast/.

3D
RENDERINGS

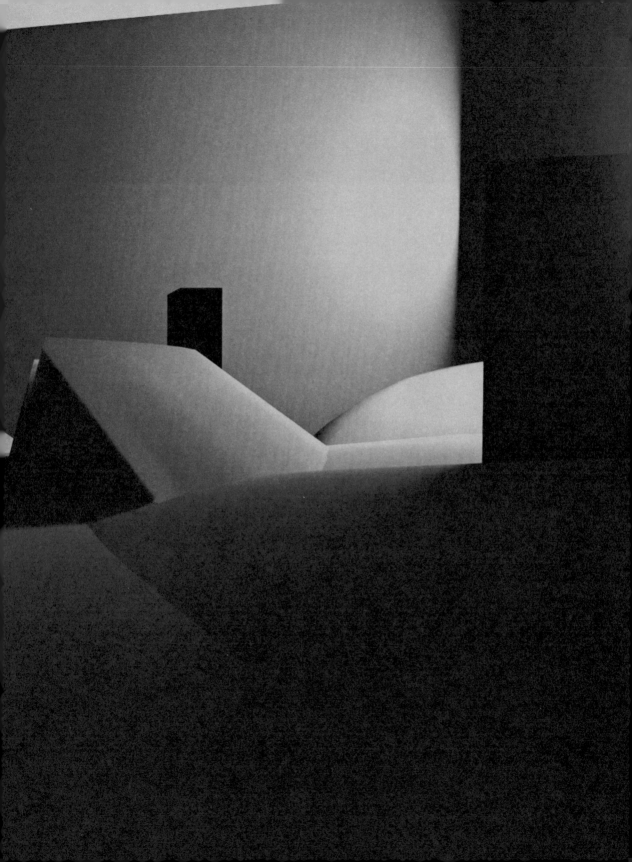

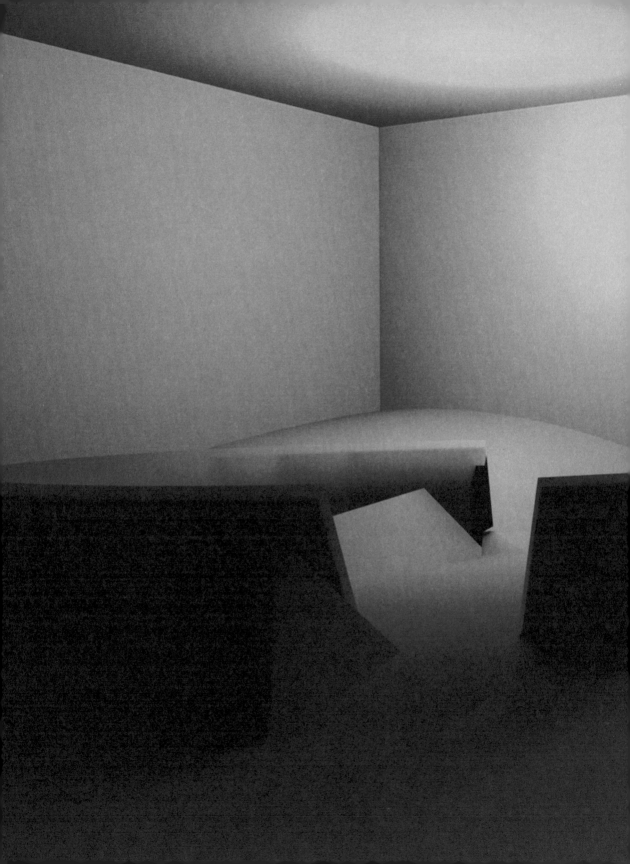

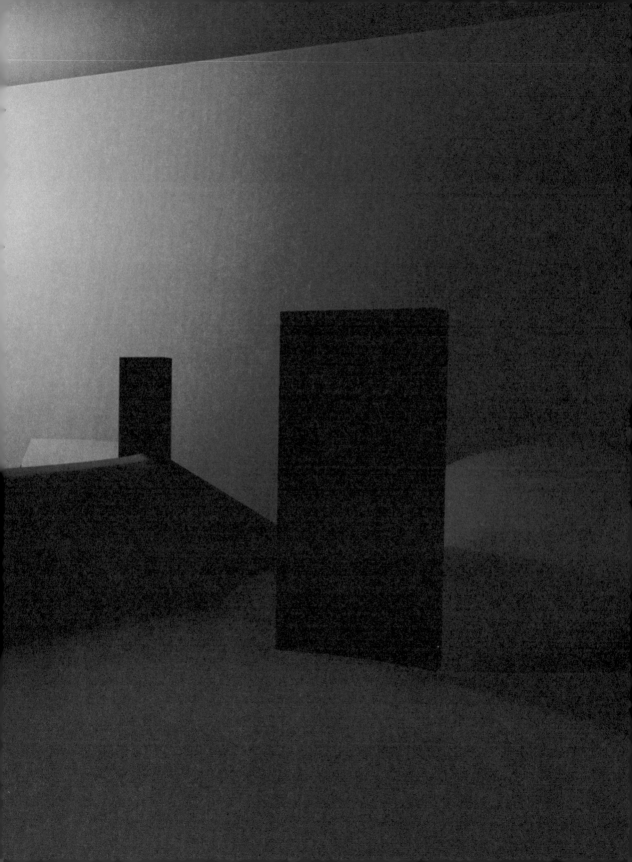

A VIVA VOCE

(WITH THE LIVING VOICE)

IRENE CALDERONI

Translated from Italian by Marguerite Shore

The commission that became NEURAL SWAMP has been a long road, with many detours, forks, and forced delays, but also new, promising design directions, in a continuous metamorphosis of ideas and artifacts that is emblematic of the way Martine Syms works. The Future Fields Commission, in fact, was conceived with the goal of offering artists a significant time span to develop an ambitious project. But with Syms, this idea has taken on an entirely different dimension, because the commission has become an integral part of a research process that develops in depth and breadth and comes together in a continual, organic, protean production. Sharing this path with the artist, it has been possible to witness this evolving mechanism, wherein a theme, a person, a device has inhabited different environments, has migrated from one form to another, progressing from being a starting point for research to playing a leading role, then becoming an element of a broader ecosystem—raw material for further manipulations.

In early 2018, in her first proposal for the commission, Syms introduced the character of Teenie, an avatar for herself, guided by AI and shaped on the example of a threat model, a computer security system expressed by the artist in psychological terms as a self-defense mechanism against external attacks. Teenie would soon become MYTHICCBEING, a multiform entity, a shadow self, materialized in a multiplicity of public occasions and display solutions, beginning with its first appearance in the exhibition GRAND CALME at Sadie Coles HQ in London in September 2018 (fig. 11). With MYTHICCBEING Syms first explored the potential of AI, but the subject of technology has always been central to her work. The concept of "thickness"—thick, but also in the sense of shapely—refers to the relationship between the human body and machines, in which the subjugation of the body to the mechanical logic of efficiency is combated with a strategy that reveals the disciplinary action of surveillance and control. Syms is interested in the transformations and potentials of technology, above all in relation to a space that she perceives as devoid of references to Black female culture, incapable of seeing, understanding, or including the racialized and gendered subject. Systems of machine learning are, in her words, "antiblack by default,"[1] and her work seeks to understand how technology can mediate these invisible subjectivities.

In her research for the development of MYTHICCBEING, Syms explored a subject that would remain a preferred realm of investigation for her

Future Fields commission: the voice. The technological means for producing an artificial reproduction of the human voice have been modified over the course of this process, but the artist's point of departure was the inefficiency of the machines, a sort of contradiction inherent to the very concept of "digital voice." Apparently it is easier to reproduce a physical semblance, an avatar-body modeled on a real body, on its gestures and movements, than a specific corporeal essence of the voice, where one encounters an impassable boundary, a humanity that is mechanically unreproducible in its singularity and physicality. In the voice, and in its destination—hearing—a dimension of physiological depth comes into play, as the philosopher and feminist Adriana Cavarero has described: "The play between vocal emission and acoustic perception necessarily involves the internal organs. It implicates a correspondence with the fleshy cavity that alludes to the deep body, the most bodily part of the body. The impalpability of sonorous vibrations, which is as colorless as the air, comes out of a wet mouth and arises from the red of the flesh."[2] On the occasion

Fig. 11

Martine Syms (American, b. 1988). *Mythiccbeing*, 2018, in *Grand Calme*, installation at Sadie Coles HQ, London, September 6–October 20, 2018

© Martine Syms, courtesy Sadie Coles HQ, London

of GRAND CALME, Syms created a live performance, along with the artist and composer Colin Self, in which she personally deployed the fleshiness of her own voice, in contrast to that of her avatar in the exhibition and to the AI that she had trained to speak as herself. It is precisely in this connection between voice and body that the mechanism of cancellation exercised by technology is systematically practiced: AI is fundamental, for example, to vocal recognition applications that we use daily, so the fact that these technologies were developed by and trained on a predominantly white population produces technological prejudices, since the apps do not recognize or adequately comprehend Black voices.[3]

Syms subsequently used her own voice, and the voices of two well-known performers, scraped from the internet, as the basis for training the three voices that constitute the three characters of NEURAL SWAMP: Athena, Dee, and Jenny, the narrator. Conceived as separate entities, each character has its own genealogy, its own DNA, its own particular cavernous and fleshy origin. In the work, these voices are attributed to footage of two flesh-and-blood actresses through overdubbing (fig. 12), and to the incorporeal entity of the narrator. The voices interact on the basis of a script, also generated in real time by AI. The text that is produced is assigned to the different entities and interpreted as though during a table read—typically the initial gathering of the cast of a film or theater production to read a script together out loud for the first time. On the one hand, then, the voices express a character, a personality, and an interpretive ability tied to a role. Thus it is not a question of a simple text-to-speech mechanism, but rather an analysis of the complexity, including the psychological complexity, of the recitation as conveyed by the human voice. On the other hand, a fundamental relationship is established between the vocal and the linguistic, both programmatically and performatively. The AI that generates the script has been instructed through an original text written by the artist, while the voices of the characters, as noted, have been developed from three different voices, that is, on the basis of distinctive uses of language, or idiolect. This linguistic material expresses a strong connection to individual performativity and in turn interacts with the production of the script, with written and spoken word reciprocally influencing one another.

This organic process has a strong symbolic presence in the work, emphasized by the monitor dedicated to the narrator, where portions

of the script appear. The centrality of the written word, and its visual appearance, is a recurring feature in Syms's work, attesting to her connection to graphic and publishing practices, but also a recognition of the increasingly important role the text message plays in today's social interactions. Previously, in her feature-length film INCENSE SWEATERS & ICE (2017), the filmic image was crowded with words, which rendered onscreen the actions of writing and reading text messages exchanged by the protagonist and her companion. In THREAT MODEL (2018), a text installation on the gallery walls conceived in dialogue with MYTHICCBEING (fig. 13), the words formed a visual map of the psychological space that the artist subsequently called SHAME SPACE (fig. 14), a place of uncomfortable introspection. Utilizing the same linguistic and communicative tools associated with digital interactions, the text installation imitated the texting between visitors and the work (many believed the responses in MYTHICCBEING came directly from Syms). Syms thus transforms words into images, shedding light on their performative and relational character as a tool for modeling the self through specific iterations and interactions. These words, however, seem to separate characters more than unite them, mirroring the way that technologies, whose promised function is to perpetually connect us to everything and everyone, in reality produce isolation, detachment, and dysfunctional relationships. This is the narrative fate of the relationship between Athena and Dee,

Fig. 13

Martine Syms. *Mythiccbeing* (still), 2018. Infinite loop, interactive video on LED panels (4:3); Stereo speakers / Sub / DAC

© Martine Syms, courtesy Sadie Coles HQ, London

frenemies caught in a loop of ambiguous courtship, in a dialogue that always comes to nothing, where the voices address one another but neither listening nor comprehension is possible.

NEURAL SWAMP is an organism in a state of becoming, not only because the entities that compose it were conceived to be nurtured and to grow, starting with the material they produce, but also because this project is an integral part of that intricate web of relationships that Syms weaves among all her works. We might consider the elements mentioned thus far as pieces of a work in progress that has at its core the creation of a film scripted through interactions between a human author (the artist) and the AI she has developed and tried out in these various projects. Like the staging of a fictitious table read, NEURAL SWAMP is both the simulation and the actual beginning of the making of a generative space that evades complete control by the artist—the control instead relegated to a technological component responding to the logic of improvisation. Adding a new dimension of complexity to the reflections deployed with this commission, the ideas that began with NEURAL SWAMP have led Syms on her most ambitious project to date—a feature film.

It has been a long journey and is far from over.

Fig. 14

Martine Syms. *Shame Space*, installation at the Institute for Contemporary Art at VCU, Markel Center, Richmond, February 16–May 12, 2019. Curated by Amber Esseiva

1. Syms, in conversation with the curator Amber Esseiva, as reported by Esseiva in an interview on the online forum LookSEE on May 13, 2019, lookthensee.com /blog/amberesseivaonmartinesyms.

2. Adriana Cavarero, *For More Than One Voice* (Palo Alto, CA: Stanford University Press, 2005), 4.

3. Cade Metz, "There Is a Racial Divide in Speech-Recognition Systems, Researchers Say," *New York Times*, March 23, 2020.

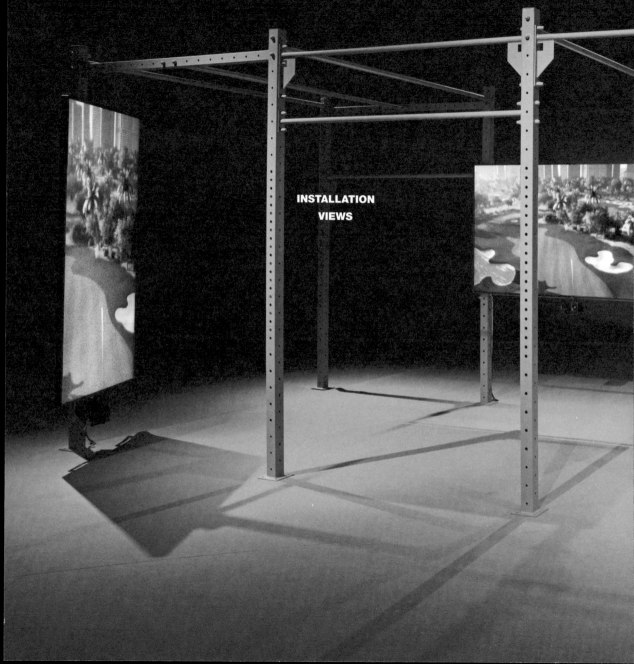

INSTALLATION
VIEWS

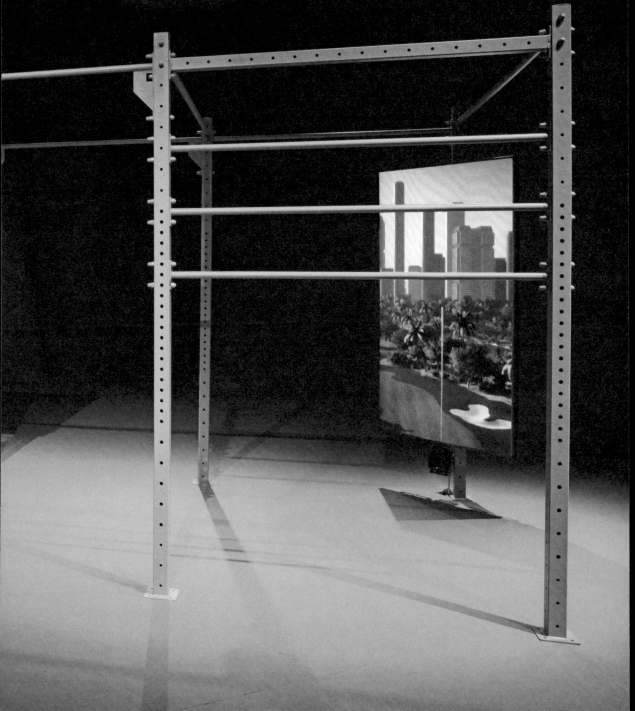

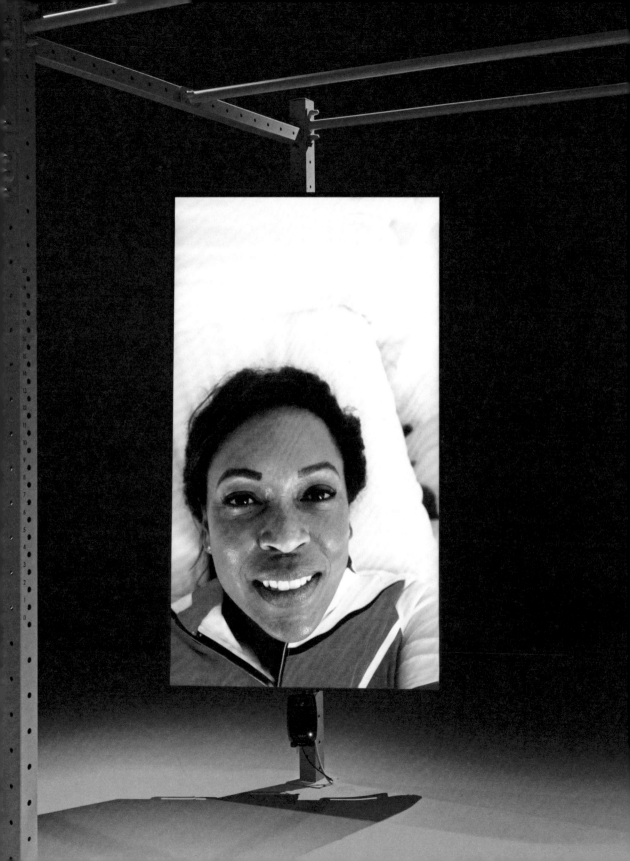

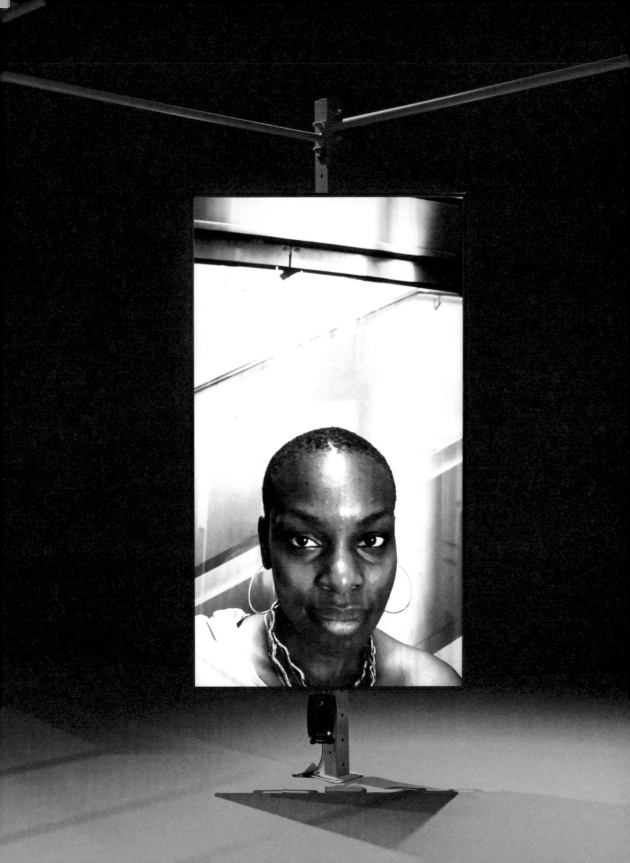

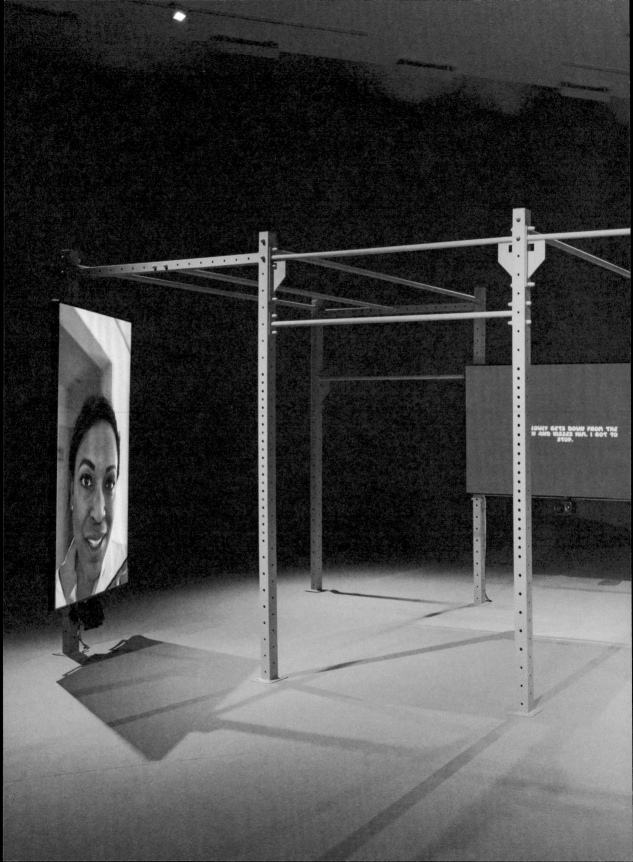

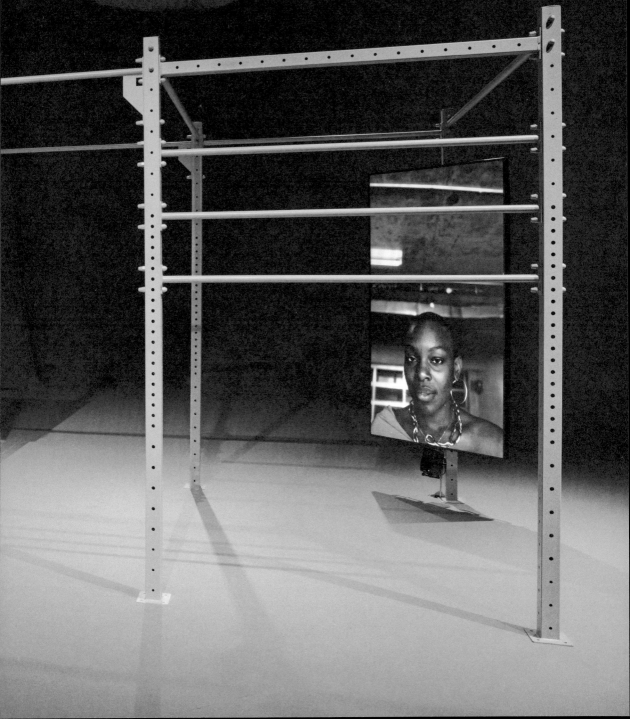

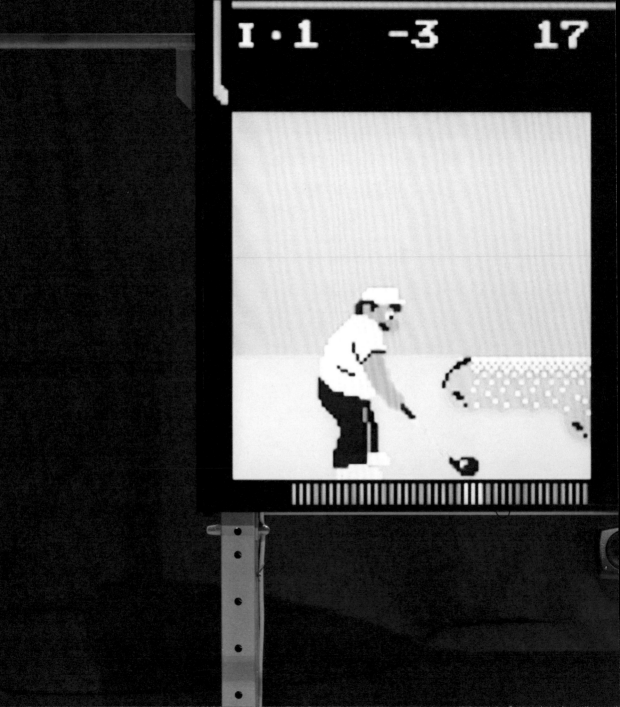

ACKNOWLEDGMENTS

IRENE CALDERONI
CHIEF CURATOR
FONDAZIONE SANDRETTO
RE REBAUDENGO

AMANDA SROKA
ASSOCIATE CURATOR OF
CONTEMPORARY ART
PHILADELPHIA MUSEUM OF ART

Four years have passed since we first asked Martine Syms to take on this commission. In that time, our lives and worlds have changed in drastic and unexpected ways. Working together to complete NEURAL SWAMP involved risk, trust, patience, and perseverance, and would not have been possible without the steadfast determination of the artist and an inspirational team of collaborators and colleagues who journeyed alongside us to bring the work, its presentation, and this publication to fruition.

We are grateful for the leadership of Timothy Rub and Patrizia Sandretto Re Rebaudengo, whose support has allowed the Future Fields Commission series to thrive and grow since its inception in 2016. We are also deeply appreciative of the sage advice and counsel provided by our curatorial colleagues Carlos Basualdo and Erica Battle.

The members of the museum's Contemporary Art Committee (p. 74) embraced Syms's commission with enthusiasm, and we thank them for their trust and encouragement—even

while facing the unknown. In Philadelphia, the exhibition of NEURAL SWAMP was kindly supported by the Daniel W. Dietrich II Fund for Excellence in Contemporary Art and the Robert Montgomery Scott Endowment for Exhibitions. The generosity of Sadie Coles HQ and Bridget Donahue, Syms's galleries, was instrumental for the commission, and support from Sadie Coles HQ was vital for the publication. Our appreciation goes to Sadie Coles, Rose Eastwood, Ariel Finch, John O'Doherty, and Ed Pennicott, as well as Bridget Donahue, Erin Leland, and Sabrina Tamar, for their commitment to Syms's work and this project.

Each Future Fields commission relies on the collective expertise and collegial spirit of our respective staffs. While many of these individuals are named on pp. 74–75, we would like to single out those whose skills, acumen, and imagination significantly informed the NEURAL SWAMP commission and presentation: at the foundation, Bernardo Follini, Giuseppe Tassone, and Silvio Salvo, and at the museum, Kate Cuffari, Stephen A. Keever, Charlotte Lowrey, Jamie Montgomery, Jay Roselius, and Alison Tufano. Our special thanks to former museum staff, including Alexis Assam for her research in the preliminary stages of the commission and publication, as well as Jeffrey Blair, Helen Cahng, and Allison McLaughlin.

This book, like the commission itself, has been a labor of learning and love and the subject of countless emails, texts, and Zoom calls. We are indebted to its editor, Kathleen Krattenmaker, whose patience and concern for every detail ensured its quality, as well as Richard Bonk, whose attention to all aspects of production ushered this volume from concept to finished book. We also thank Katie Reilly, who early on guided the vision for the publication, and Katie Brennan, for her careful proofreading. Our thanks to the brilliant scholar and writer Christina Sharpe for her poignant essay and enlightening insights into Syms's work and its relevance both culturally and art historically. We are also grateful to Brent David Freaney, Clarissa Ebigwu, and Jack Staffen at Special Offer, Inc., whose perceptive approach to Syms's work and involvement in the production of the commission informed the book's design. Our additional thanks to designer Rebecca Quinn for her sensitivity in executing the final changes to this volume.

Syms is surrounded by an extraordinary network of collaborators, many of whom were integral to the production of NEURAL SWAMP. Together with the artist, we extend our gratitude to Rocket Caleshu, Lydon Frank Lettuce, Jake Nadrich, Kaitlyn Battistelli of Ethos Studio, Jack Staffen and Brent David Freaney, Crystal Coney, Clarissa Ebigwu, and Shyan Rahimi. We offer further thanks to Paolo Barbieri and Rajan Craveri for their technical assistance, and to Rocket Caleshu, Natalie James, and Brandon Malone at Dominica, Inc., for their diligence and dexterity in navigating the commission's development and presentation.

Finally, and most importantly, our heartfelt thanks and infinite gratitude go to Martine Syms for her dedication and thoughtful approach to this visionary commission.

NEURAL SWAMP is a pivotal work of our time, and we look forward to sharing it with our audiences now and in the years to come, as our complex relationships with technology—and with one another—continue to emerge, glitch, and form anew.

NEURAL SWAMP Credits

Martine Syms: director & writer
Rocket Caleshu: producer & writer
Lydon Frank Lettuce: production assistant
Jake Nadrich: editor
Kaitlyn Battistelli / Ethos Studio: colorist
Jack Staffen and Brent David Freaney /
Special Offer, Inc.: engineering
Crystal Coney: "Athena"
Clarissa Ebigwu: "Dee"

Thanks to Shyan Rahimi for the location.

Photography Credits

Fondazione Sandretto Re Rebaudengo,
photographs by Sebastiano Pellion
di Persano: pp. 6–7, 64–71
Robert Glowacki: fig. 11
David Hunter Hale: fig. 14
Keith Hunter: fig. 8